시티 라이프 CITY LIFE 따라 그리는 약국 일러스트 드로잉북

DRAWING MANHWA

CITY LIFE

T0182755

Published in the United States by:
ULYSSES PRESS
PO Box 3440
Berkeley, CA 94703
www.ulyssespress.com

First published in Korea in 2012 as 시티라이프 (CITY LIFE) by 약국 (YAKKUK).

This translated edition was published by arrangement with KL Publishing Inc. through Shinwon Agency Co.

ISBN: 978-1-64604-721-5
Library of Congress Control Number: 2024934550

Printed in the United States
10 9 8 7 6 5 4 3 2 1

NOTE TO READERS: This book is independently authored and published and no sponsorship or endorsement of this book by, and no affiliation with, any trademarked brands or other products mentioned within is claimed or suggested. All trademarks that appear in this book belong to their respective owners and are used here for informational purposes only. The author and the publisher encourage readers to patronize the brands mentioned in this book.

시티 라이프 CITY LIFE 따라 그리는 약국 일러스트 드로잉북

DRAWING MANHWA

CITY LIFE

BY **YAKKUK**
약국 지음

HOW TO DRAW YOUR OWN WEBTOONS & WEBCOMICS

ULYSSES PRESS

Author's Note

The ballpoint pen is an old friend that everyone has used at least once. It seamlessly integrates into our daily lives, whether we are jotting down necessary information, writing letters, taking notes in school text-books, or doodling on scraps of paper. However, it is not particularly popular as a tool for drawing. Compared to mistakes made in pencil, ballpoint mistakes are harder to correct, and ballpoint offers a simpler palette than pencils or watercolors. Additionally, digital graphic tools have grown in popularity over traditional drawing methods. Despite this, I harbor a fondness for drawing in ballpoint. I appreciate the unique texture and physical properties of ballpoint ink when it meets paper, along with the comfort and allure of using a familiar tool. My first drawing book, *Drawing Manhwa: City Life*, explores the charm of the ballpoint pen. This book is themed around the everyday and spe-cial moments one encounters in the city and includes step-by-step sketching exercises as well as twenty-four completed illustrations.

Do not fret if this is your first foray into ballpoint pen drawing. This book will impart fundamental techniques for ballpoint pen drawing and provide ample space for you to practice. Observe and enjoy the outcomes of different angles, directions, and pressures. Whether you're unwinding at home after a day's work or leisurely spending time in a cafe on a rare day off, seize the opportunity to delight in ballpoint pen drawing anytime, anywhere. While my completed works are included as a guide, I encourage you to experiment with your own techniques. I hope this book will help you discover the rugged yet gentle charm of the ballpoint pen that you may not have known before.

약국
Yakkuk

Table of Contents

Materials 9

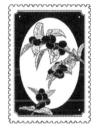

Drawing Terminology 15

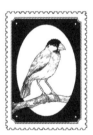

Introduction to Techniques 19

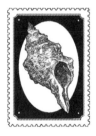

Drawing Practice 55

Materials

Ballpoint Pens

The ballpoint pen is a basic tool that can draw thin, smooth lines. Ballpoint pens can generally be categorized as water-based, oil-based, or gel-based; my preference is for gel-based. Below is a description of each type of pen.

Water-Based

Water-based ballpoint pens have a low ink viscosity, similar to water, which allows for a pleasant drawing experience and the ability to render sharp lines. However, they have the tendency to smear when in contact with water.

Oil-Based

Oil-based ballpoints do not smear in water, which is a significant advantage. Due to the ink's high viscosity, however, an oil-based ballpoint line drawn over multiple times can result in clumping, and the ink may not dry quickly, making this option less suitable for drawing except in specific cases.

Gel-Based

Gel-based ballpoint pens avoid the drawbacks of both water-based and oil-based pens. The gel ink combines low viscosity and smooth application with smudge resistance.

TIP

When you are drawing, ink may clump up on the tip of a ballpoint pen, resulting in thick, messy lines. You can prevent ink clumps by periodically wiping the tip with a soft tissue.

Signo 0.28

The Signo 0.28, a gel-based ballpoint pen, excels in rendering thin, precise lines. You can vary the thickness by adjusting your grip or drawing speed, as illustrated below. While gel pens like the Hi-Tec-C are also popular for their fine tips, their fragility and excessively thin lines may not be suitable for beginners. The explanations and techniques described in this book are based on the use of the Signo 0.28.

When drawn quickly, the line is thin with a sharp end, giving the impression of it swiftly trailing off.

When drawn slowly with pressure, the line is thicker, with a consistent width from start to finish.

Brush Pens

Unlike markers or colored pencils, brush pens blend seamlessly with gel-based ballpoint pens, minimizing any sense of incongruity. Therefore I often use them for filling in larger areas. They also provide a slightly moist texture that ballpoint pens cannot. Below are some considerations for selecting a brush pen.

Brush
A brush pen, true to its name, is a pen with a brush tip, making it highly sensitive to pressure. The thickness of the stroke can vary significantly between a deep press and a light touch, much more so than with ballpoint pens. For beginners, I recommend a brush with a bit of firmness and elasticity.

Light pressure Firm pressure

Ink
When using a brush pen for filling areas or blending with gel-based ballpoint pens, opting for too light an ink can be counterproductive because the ink won't blend well with the ballpoint pen and achieving the desired effect may be challenging.

TIP

When filling a narrow area, use a light touch. For a broader area, press firmly and sweep across. Rapid and extensive coverage over large areas can result in a diluted ink appearance, resembling blotches. In such instances, layer multiple coats, allowing adequate drying time between applications.

Single coat First layer Second layer

Tombow Dual Brush Pen

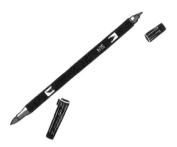

The Tombow Dual Brush Pen features a brush on one end and a fine-liner tip on the other. The fine-liner tip is perfect for filling in small areas or outlining the areas to be shaded, while the brush end is ideally suited for covering larger spaces. Additionally, the brush is not overly soft, making it manageable for beginners to control, and it offers a suitable level of opacity.

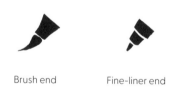

Brush end Fine-liner end

Drawing Terminology

Sketches and life drawings emphasize shading and tonal variations. In contrast, my focus lies primarily in outlining objects or figures with clean, precise lines, or "line drawing." In my work, I use this technique along with comic-style exaggerations and simplifications rather than striving for photorealistic representation. The following terms are frequently used in the comic industry as well as in this book. Becoming familiar with these terms will help you learn about some common drawing techniques that can enrich your process.

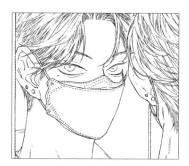

Pen Touch

The process of using a pen to define shapes in and add details to a sketch.

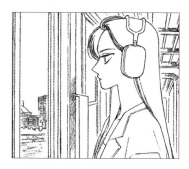

Outline

The cleanly traced line that defines the border of an object or figure.

Inking

To color in an area completely with ink using a brush pen or other drawing tool over pen lines.

Hatching

A set of uniform parallel lines primarily used to depict shadows, textures, or light; hatching allows for a variety of tones and textures based on how the lines overlap.

TIP

Hatching can convey a clean, stark texture or shading. This book will exclusively cover contour-hatching.

Gradient

A gradual transition between dark and light, ensuring each stage blends smoothly into the next.

Introduction to Techniques

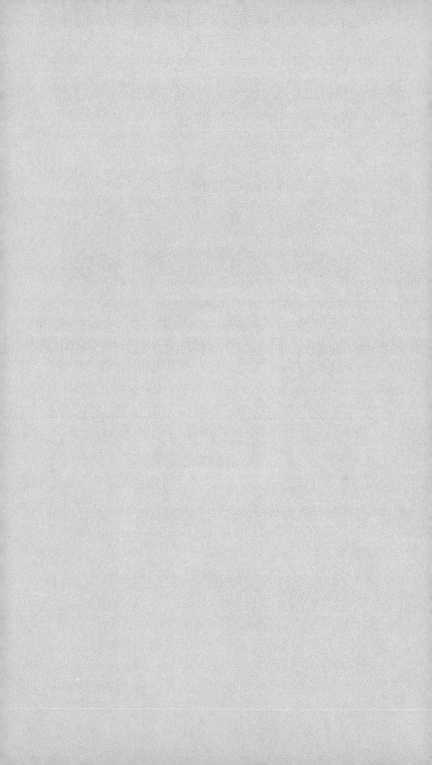

Fundamentals of Ballpoint Pen Drawing

1. Basic Posture

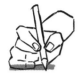

Hold the pen comfortably, resting the side of your hand and pinky finger on the paper. This posture ensures that lines do not wobble or become uneven.

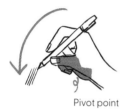

Pivot point

When drawing lines, use the side of the hand touching the paper as a pivot point, letting your wrist rotate. This book emphasizes using short lines to complete drawings, particularly when cross-hatching, so it's essential to maintain this posture to enable smooth line work.

TIP

For right-handed individuals: Rest the side of your hand on the paper, keeping your weight there. When drawing diagonals, swiftly execute lines from the top right to the bottom left.

For left-handed individuals: Rest the side of your hand on the paper, keeping your weight there. When drawing diagonals, swiftly execute lines from the top left to the bottom right.

2. How to Draw Outlines

When drawing spheres or cubes, maintain the basic ballpoint pen drawing posture and gradually draw short lines while fluttering the tip. To avoid any lines sticking out of the shape, neatly overlap the short lines and smoothly connect them. See page 57 for practice.

Correct example of gradually connecting short lines with tapered ends

Incorrect example where the basic posture is not maintained, resulting in stray lines

3. How to Draw Hatching

Basic Hatching
This technique is often used to depict light and shadow. Maintain the basic posture for ballpoint pen drawing and draw lines with as much uniformity of spacing and length as possible.

Hatching with Tapered Lines
This type of hatching is used to create the effect of light lines or to connect short lines and is ideal for depicting sparkling materials or dry textures, and for seamlessly blending the ends of shaded areas. Relax your hand and quickly draw lines from top to bottom along the diagonal.

Layering Hatching

Hatching is utilized to convey shadow, texture, or tone. Layer the lines in an overlapping manner irregularly, at the same angle. Stacking lines in a straight row will make the overlapping sections stand out like a pattern.

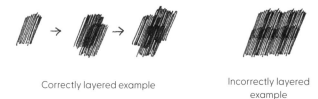

Correctly layered example

Incorrectly layered example

Expressing Three Levels of Tone with Hatching

Tone varies depending on factors like the pressure applied or the shape of the line ends. In this book, tones are categorized into dark, medium, and light. Dark and medium tones are created with basic cross-hatching, while light tones are achieved by tapering the ends of the lines.

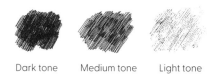

Dark tone Medium tone Light tone

Expressing Gradients with Hatching

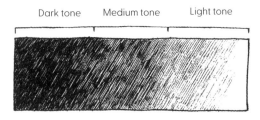

Dark tone Medium tone Light tone

To create a gradient, fill the area in with dark, medium, and light tones, gradually transitioning the intensity. The key is to create a smooth progression between tones. See page 59 for practice.

Depicting Light and Shadow on Spheres and Cubes

Using the gradients created with hatching can enhance the three-dimensionality of objects. Observe the light and dark areas carefully and divide them accordingly. See page 60 for practice.

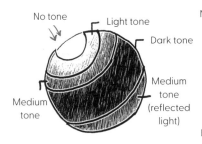

No tone
Light tone
Dark tone
Medium tone (reflected light)
Medium tone

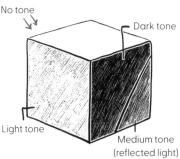

No tone
Dark tone
Light tone
Medium tone (reflected light)

Sphere
Start with light tones, progress to medium tones, and then to dark tones, increasing in intensity. At the point where the sphere meets the ground, use medium tones to show reflected light.

Cube
Represent each of the three sides in a different tone. As with the sphere, create a realistic effect by showing the area where the cube meets the ground reflecting light and appearing slightly brighter.

4. Techniques for Inking

Filling Large Areas

When filling large areas, consider using a brush pen. First, outline the area to be inked with a fine-liner, then apply slight pressure with the brush to lay down dense, broad strokes. If streaking or blotchiness occurs, allow the ink to dry completely before applying additional coats (see page 13). See page 61 for practice.

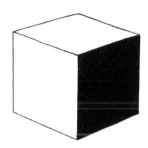

Filling Small Areas

Hold the brush pen lightly and taper the ends of your strokes as you fill in (see page 13). For areas that are too sharp or small to ink effectively, leave them unfilled to be completed later with a ball-point pen. See page 62 for practice.

5. Using Hatching to Integrate Inking

Use hatching to connect an inked area to an uninked one. Start by over-laying dark tones with a ballpoint pen where the uninked area meets the inked area. Then transition to medium and light tones to naturally blend the boundary. Combining inking with hatching vividly depicts depth perception as well as textures such as hair and other material qualities. See page 63 for practice.

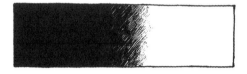

Inked and uninked areas integrated with hatching

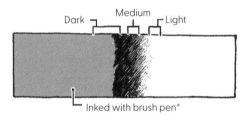

Dark Medium Light

Inked with brush pen*

*Shown here in gray to denote the area, but it would be black in your drawing.

6. Combining Inking and Hatching

Expressing Hair Texture

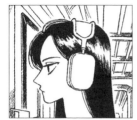

By leaving areas where light hits uninked and smoothly connecting the hatched and inked edges, you can give hair a glossy appearance.

Depicting Other Textures

For surfaces like water, glass, or leather that shine when lit, the same technique of leaving highlights uninked and connecting them with hatching will bring out their unique textures.

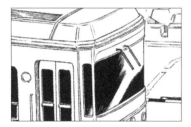

Conveying Depth

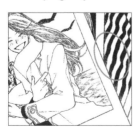

When objects overlap, hatching can define their boundaries and help separate them while simultaneously conveying a sense of depth.

1. Mastering Hatching and Inking

See *Space Odyssey*, pages 64–65

Starting with Pen Touch

When beginning with narrow areas or detailed subjects, there's a natural tendency to lean in, narrowing your field of view and potentially losing sight of the overall composition, which can lead to the distortion of objects or figures. To prevent this, start by outlining the contours of large, simple objects. Before you begin, refer to the basic posture for ballpoint pen drawing on page 21.

TIP

For beginners, drawing long lines cleanly in one go can be challenging, so start by gradually connecting short lines. See page 22 for reference.

Drawing Outlines

When drawing outlines, start with the foreground and then proceed to the background. For this drawing, begin with the outline of the car, followed by the figure, the desert, and finally the planets. Using darker lines for objects closer to the viewer and lighter lines for those farther away adds a sense of distance and depth.

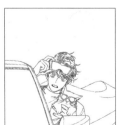

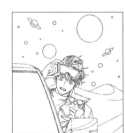

Drawing the Planets

Once you've drawn the outlines, move on to filling in the planets. The planets are the most distant objects, so painting them with a brush pen will make them appear clearer and closer. Instead, be sure to fill in the details by hatching diagonally with a ballpoint pen.

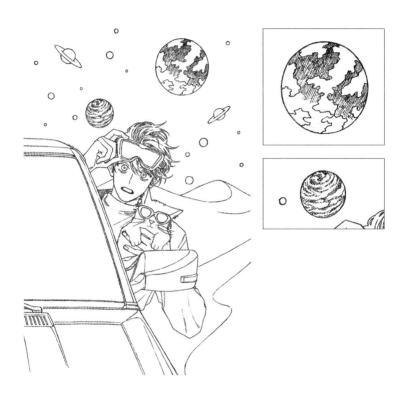

TIP

Avoid dark tones and instead mix medium tones with light tones so the planets don't look too close to the foreground. For information on how to give the planets a three-dimensional effect, see page 24.

Detailing the Desert

The desert lies between the car in the near field and the planets in the distance. However, unlike the planets, which have a mixture of dark and light patterns, the desert is made up of only light colors, so the light and dark must be expressed in much lighter tones than the planets. Add light-toned diagonal hatching (see page 23) by holding the ballpoint pen at a very slight tilt and drawing with a light touch. Retain some white space between the hatching in the desert and the outline of the human body.

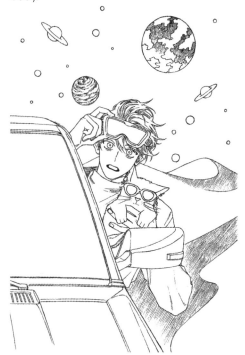

TIP

By leaving a space between the background and the character, a richer sense of distance and depth can be expressed. This principle can be applied to any drawing where the edge of an area in the background touches an object in the foreground.

Detailing the Texture of the Car Windows and Goggles

Car windows and goggles shine in the light. To bring out this texture, decide where the light will reflect before inking. Next, as shown in the detail, the part that is next to the area to be inked should be hatched with a dark tone, whereas the part that is next to the area where light will be reflected should be hatched with a light tone. Don't forget to add this texture to the cat sunglasses.

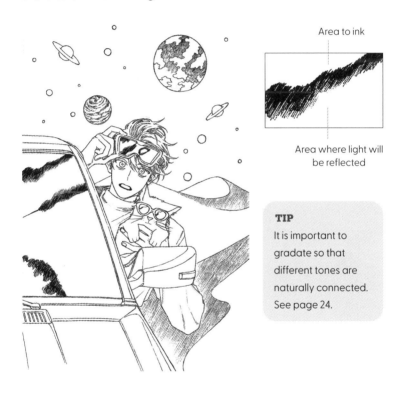

Area to ink

Area where light will be reflected

TIP

It is important to gradate so that different tones are naturally connected. See page 24.

Preparing to Paint the Background

The background (deep space) will be inked in. The firm, broad strokes made with a brush pen while inking can easily encroach on other areas. To prepare for this, use the tip of a brush pen or a fine-liner to draw a thick border around objects to be inked around.

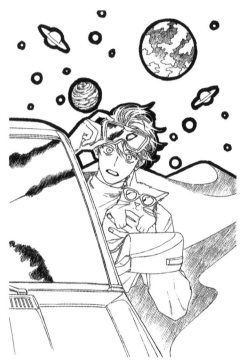

TIP

For delicate and difficult areas, such as between locks of hair, it's better to fill in the details with a ballpoint pen instead of a brush pen or fine-liner.

Painting the Car Windows and Goggles

Leave the areas where light reflects uninked and use a brush pen to create a natural connection between the inked area and the hatching. As with the background, it is best to first draw a thick border inside the outline of the area to be inked, such as in the windshield, goggles, and cat sunglasses.

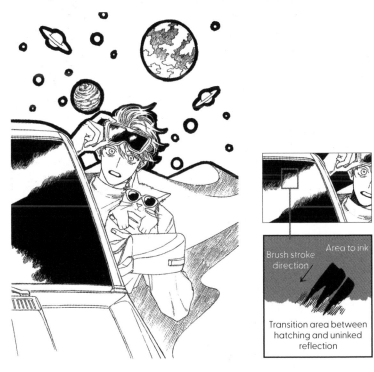

Brush stroke direction

Area to ink

Transition area between hatching and uninked reflection

TIP

Use firm pressure where the brush stroke begins in the area to be inked, then release the pressure and flick the stroke to naturally connect it to the hatched area. The direction of brushing starts in the area to be inked and ends at the hatching.

Completion

Lastly, ink the background with a brush pen and you're done. Firmly press the brush and apply deep, thick strokes. If the inking is blotchy, add another coat after the first layer has dried sufficiently.

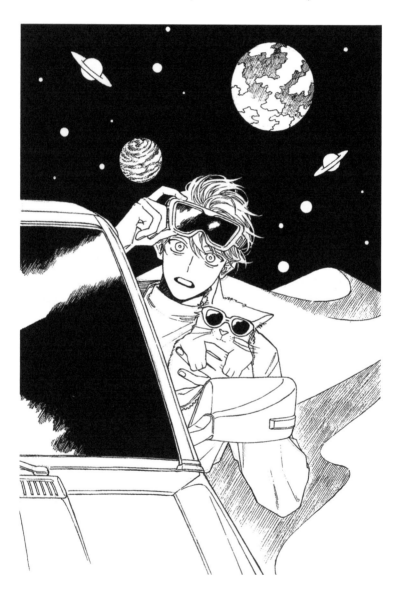

2. Learning to Express Details

See *Angel's Realm,* pages 66–67

Getting Started with Pen Touch

Begin by drawing an outline of the character and then the background. If you draw detailed parts of the character first, such as the necklace, eyelashes, or hair, the overall shape may become disorganized. See page 21 for basic ballpoint pen drawing posture.

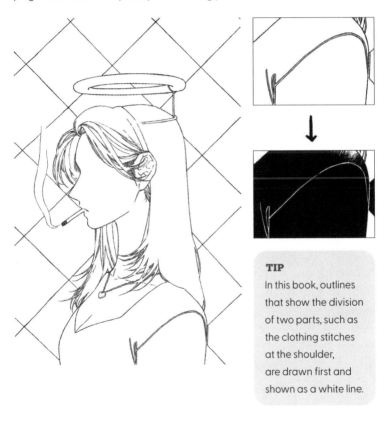

TIP

In this book, outlines that show the division of two parts, such as the clothing stitches at the shoulder, are drawn first and shown as a white line.

TIP

For the necklace chain, first draw one side, using linked semicircles. Then draw the other side using semicircles that face the upper set. This will be easier than drawing the necklace links one by one.

Drawing the Eyes and Eyebrows

First, outline the eye, then proceed with the iris, eyelashes, and eyebrows, in that order. Drawing each eyelash and eyebrow strand delicately is crucial for achieving a natural appearance.

1) Drawing Eyelashes

Start from the inner rim of the eyelid and draw outward. It's essential to begin with a thicker line near the rim that tapers to a sharp point at the end.

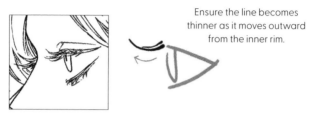

Ensure the line becomes thinner as it moves outward from the inner rim.

2) Drawing Eyebrows

Line direction is crucial for eyebrows. Mimic the natural orientation of eyebrow strands by drawing thin, short lines.

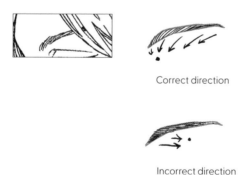

Correct direction

Incorrect direction

Drawing the Hair

In portraits that feature only the upper body, the face naturally becomes the focal point. Therefore, if the edge of the hair around the face (such as the hairline above the forehead or at the the nape or the back of the neck) appears awkward, it can significantly affect the overall impression. Try drawing these areas with thin, light lines. The lines do not need to be continuous.

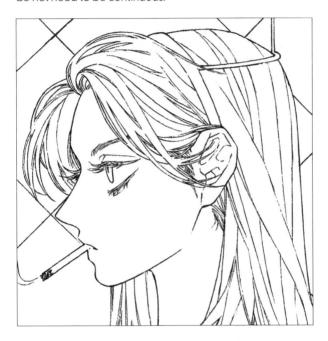

TIP

While capturing the general flow of the hair is essential, it's crucial to start with detailed strokes around the areas where the hair meets the face: above the forehead and at the nape and the back of the neck.

Expressing the Hair Details

Begin detailing the hair at the forehead area, closest to the face, and then move back toward the crown and then downward to the flowing sections. Avoid drawing hair in large chunks, as this can reduce the overall quality of the drawing. Conversely, segmenting the hair too much can distract the viewer's attention toward those sections rather than guiding it to the face.

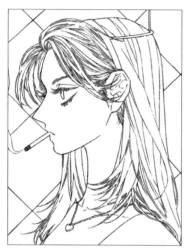 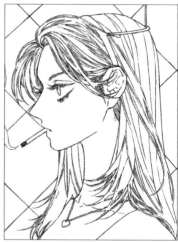

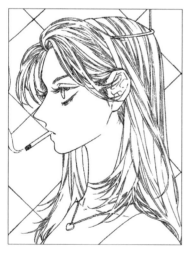

Using Hatching

Before inking the background, apply hatching around the areas where the figure and other objects meet the background. Focus on selected parts of these boundaries to make the panel appear more refined and soft and to add more natural separation between the figure and the background. Adding hatching to clothing can also enhance texture.

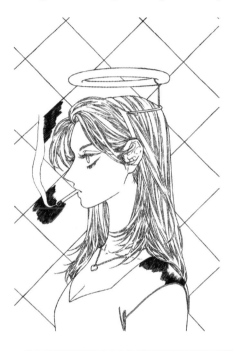

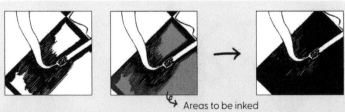

Areas to be inked

TIP

When inking areas around the cigarette and the shoulders, it's possible to encroach on the hatching zones. Therefore, extend the hatching beyond the needed areas. This approach ensures a seamless transition between ink and hatch.

Preparing to Ink the Clothes and Background

Before inking the figure's clothes and the background, use the tip of a brush pen or a fine-liner to first draw a thick outline inside the contours to prevent the brush pen from encroaching on other areas when inking.

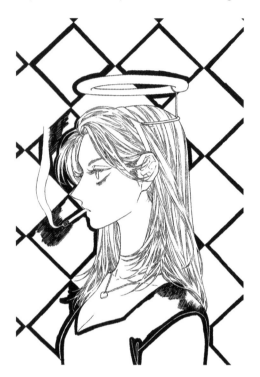

TIP

For areas with sharp ends and narrow spaces that are difficult to ink, such as the ends of hair, it's easier to fill them using a ballpoint rather than a brush tip.

Completion

The final step involves filling in the clothes and background with the brush pen. Apply firm pressure, covering the area with dense, broad strokes. If any streaking or blotchiness occurs, allow the ink to dry completely before applying additional coats.

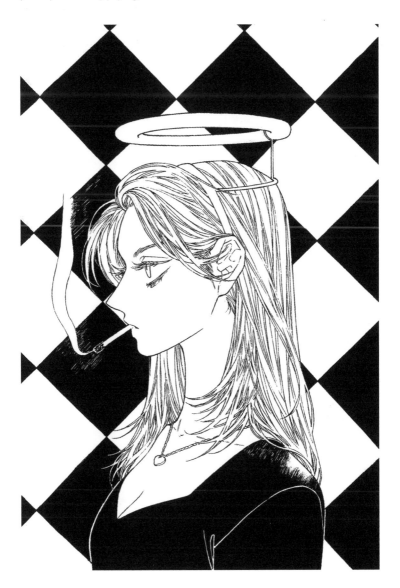

3. Mastering the Expression of Black Hair

See *Good for You*, pages 68–69

Drawing Outlines

In illustrations where the figure prominently stands out against a minimal or nonexistent background, start by drawing the elements that are in the foreground, such as the hands, wine glass, and jug, before moving on to the figure. Begin with the outline of the face and save the cigarette for last.

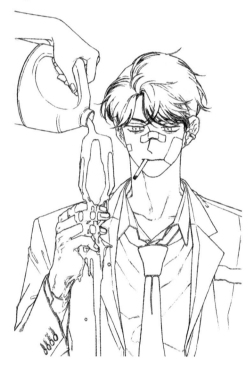

Detailing

Draw details such as the label on the jug, bandage patterns, and the character's wounds. Make the bandage patterns by lightly dotting with a ballpoint pen and depict the wounds with light-toned, small hatching.

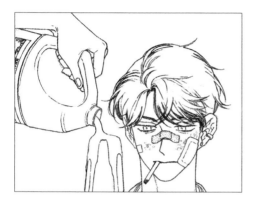

Expressing Black Hair

Black hair looks lustrous when the areas where light touches it are left uninked, creating a glossy effect. Uninked areas should be left around the crown of the head, resembling a rough halo or irregular circle. The areas adjacent to the gloss should be hatched with light tones, while the sections that will be inked should be hatched with darker tones.

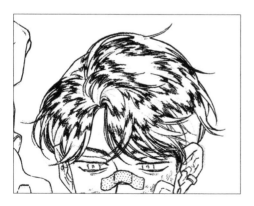

Inking

Begin with the fairly simple jug label, then move on to the relatively larger area of the tie, and finish with the hair. Be careful to stay within the pre-drawn outlines and try to naturally blend the hatching.

TIP

When filling in narrow areas like the ends of hair or around hatching, use the tip of the brush to apply short, light strokes. For larger areas, use firm pressure for thicker lines.

Light pressure Firm pressure

Adding Shadows

Adding shadows to areas like the neck and shoulders enhances the three-dimensionality. Start by creating dashed lines around the areas where you plan to add shadows, then fill the area in with medium-toned hatching. For the most natural look, ensure that these lines are thinner than the main outline of the drawing.

Completion

Finally, check for any streaking or blotchiness in the completed piece and add finishing touches as needed.

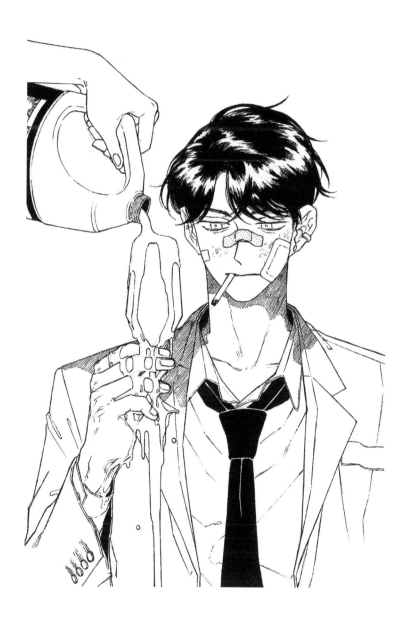

4. Determining the Order of Drawing for Scenes with Multiple Elements

See *For the Young Audience*, pages 70–71

Determining the Order of Drawing for Scenes

To create a scene bustling with numerous objects, begin by distinguishing between the foreground and the background, then proceed to draw from the nearest to the farthest elements. Here, the sequence should follow the order of stuffed animals, books, figure, guitar, shelf. The posters on the wall and the pattern on the floor should be drawn last.

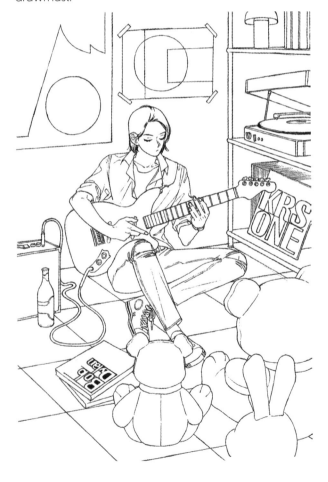

Drawing the Outlines of the Stuffed Animals and Books

Begin with the rabbit, the stuffed animal positioned closest to the viewer, followed by the bear on the left, and then the bear on the right. Next, draw the stack of nearby books.

Drawing the Outlines of the Figure and Guitar

Start by tracing the outer contour of the figure and guitar. Then draw the hairline around the forehead, marking the boundary between the head and the face. Also capture the nape of the neck. When drawing the ends of the hair, use swift strokes to create sharp tips, bearing in mind that the hair will be represented as black, so it's unnecessary to detail every strand. Following this, proceed to the facial features and details such as the folds of the clothing and guitar fingerboard.

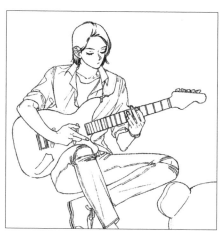

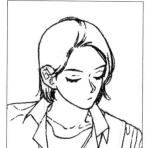

Drawing the Beer Bottle and the Amplifier

Given that the guitar amplifier and the cables are behind the beer bottle, draw the bottle first, followed by the amplifier and the cables. Ensure that the outlines do not encroach on other objects in the scene. Once these elements are complete, refine the details of the guitar and the sneakers.

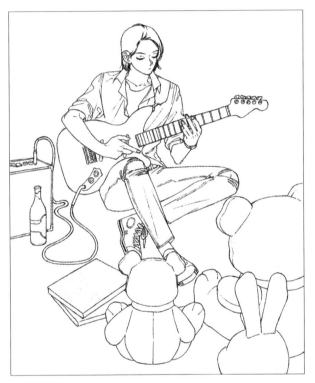

Drawing the Shelf

Begin by sketching the large shape of the shelf, drawing from the top down. When illustrating the records on it, clearly define the front lines, using a lighter touch for the top lines, flicking the pen to prevent the lines from becoming too prominent. Be careful to avoid encroaching on the guitar.

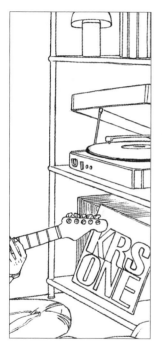

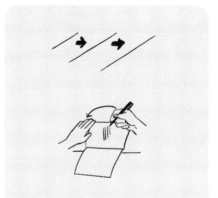

TIP

When drawing long lines, such as those for the shelf, make short segments and connect them gradually (see page 22). Find a comfortable angle by rotating the sketchbook as you draw. This will allow you to produce clean, long lines. For practice, see page 58.

Drawing the Poster and the Floor Pattern

Follow the sketch to draw the posters on the wall and the pattern on the floor. Add the lettering on the book covers.

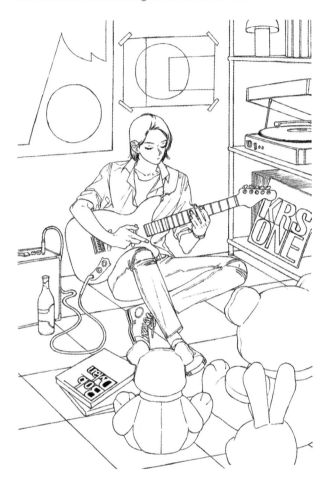

Drawing the Guitar Strings

Using a method similar to that used for drawing the shelf, draw the guitar strings by gradually connecting short lines to form longer ones. Avoid allowing any stray lines to escape the intended path and ensure that the strings do not encroach on the fingers.

Expressing Texture

Use hatching to depict the textures of the hair, guitar strap, amplifier, and the record on the turntable. For the hair, create a slightly rounded shape around the crown, akin to a halo, and apply hatching (see page 43) before shading to give it a glossy appearance. When hatching the guitar strap, consider where the light will hit it, and hatch the record to accentuate its grooves.

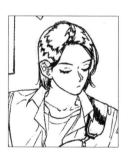
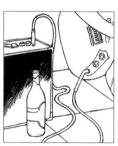

Applying Ink

Before inking, use the tip of a brush pen or a fine-liner to draw a thick border inside the outlines. Although the order of inking is not important, consider starting with objects that are closer to the viewer. Begin with the book, followed by the amplifier, record, and then the floor. For filling in delicate areas such as hair, the record, or text, use the tip of a ball-point or felt-tip pen. Feel free to ink the posters in any style you like.

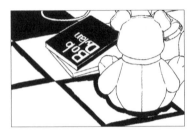

Expressing Light and Shadow

In this illustration, broad areas will be filled with either light or shadow. Shadows that are too light will diminish the overall brightness of the picture, while tones that are too dark may result in a messy or rough appearance. Strike a balance by shading with diagonal hatching in a medium tone (see page 23).

 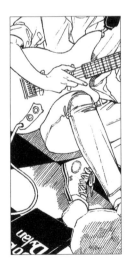

Completion

As you get closer to completion, review the overall illustration, making adjustments to the shading or tonal values as necessary to enhance the visual appeal and coherence of the piece.

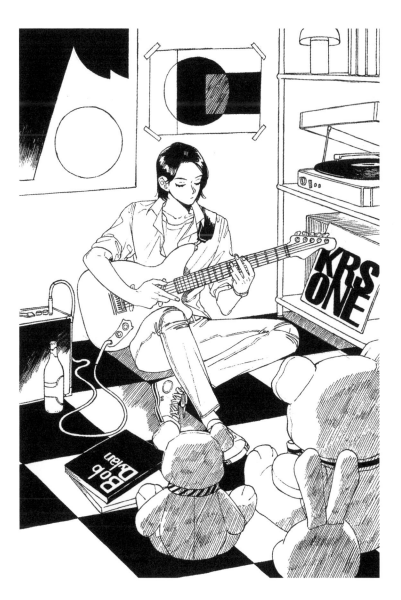

Yakkuk's Principles of Pen Drawing

Start with Elements That Catch the Eye First
Foreground \rightarrow background

Outline \rightarrow detail

Large forms \rightarrow small forms

Use Pressure to Convey Depth
Objects closer to the viewer should be drawn with bold lines and hatched with dense tones. Objects farther away should be rendered with lighter lines and tones.

Inking Begins with the Borders
Prior to inking, draw a border inside the outlines of the area to be inked. For intricate details, fill in using the tip of a ballpoint or felt-tip.

Drawing Practice

Contour Practice

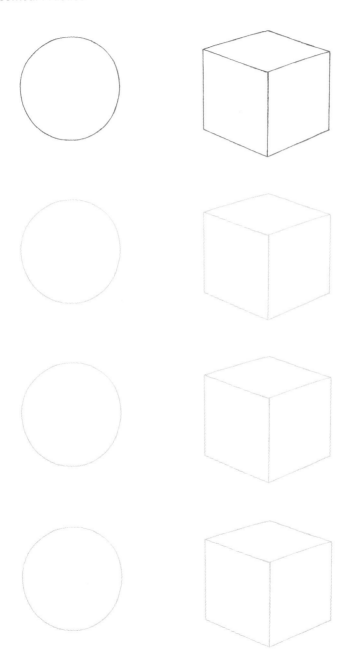

Long Line Practice

Diagonal Hatching Gradation Practice

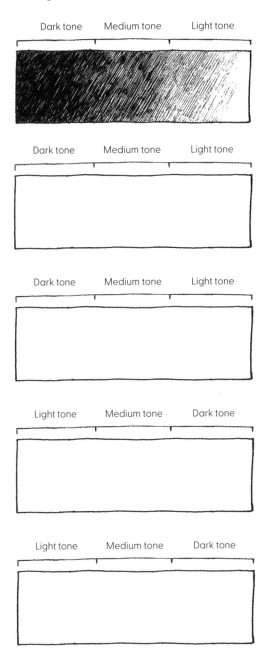

Dark tone Medium tone Light tone

Dark tone Medium tone Light tone

Dark tone Medium tone Light tone

Light tone Medium tone Dark tone

Light tone Medium tone Dark tone

Shading Practice

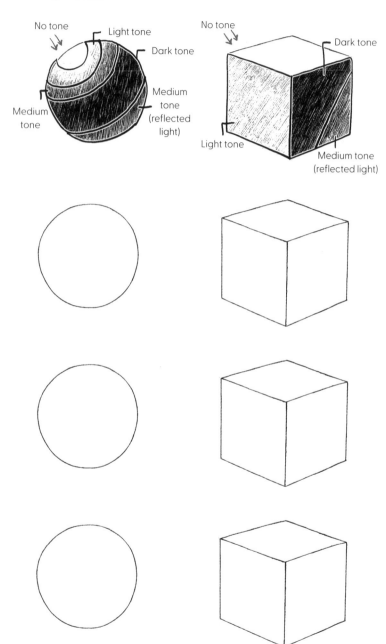

No tone

Light tone

Dark tone

Medium tone (reflected light)

Medium tone

No tone

Dark tone

Light tone

Medium tone (reflected light)

Inking Large Areas Practice

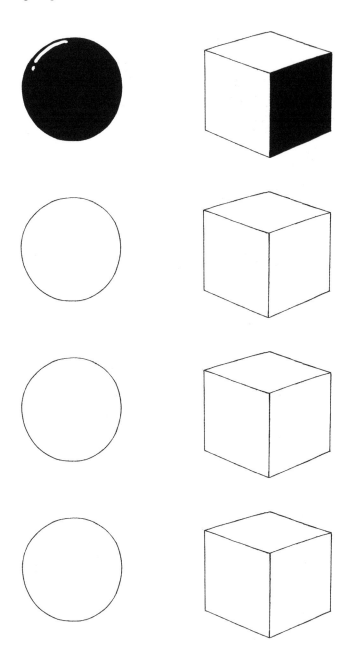

Inking Small Areas Practice

Connective Hatching Practice

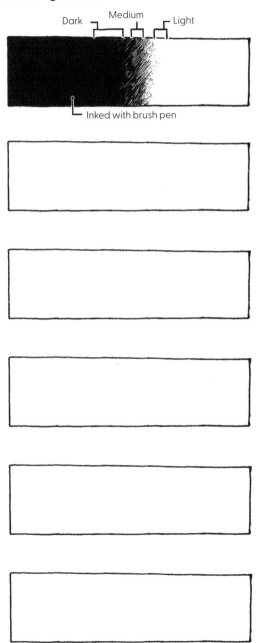

Dark Medium Light

Inked with brush pen

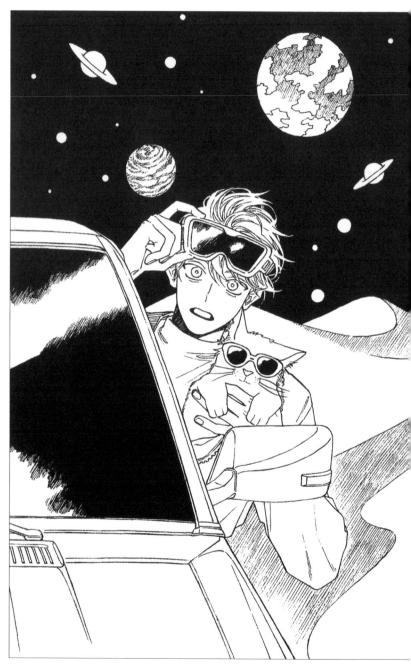

Space Odyssey

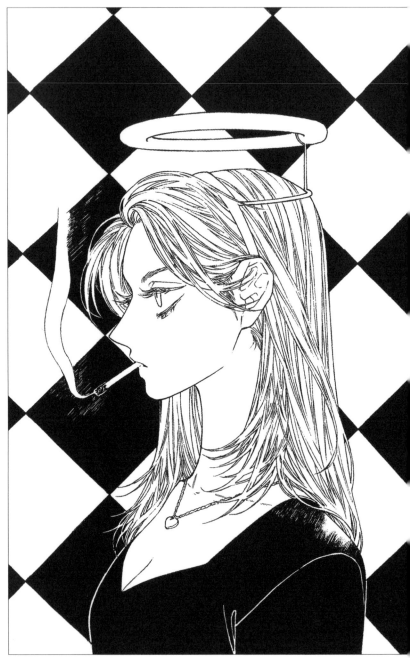

Angel's Realm

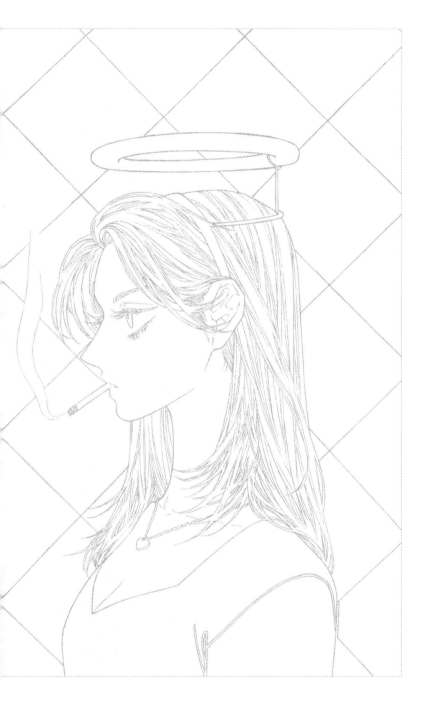

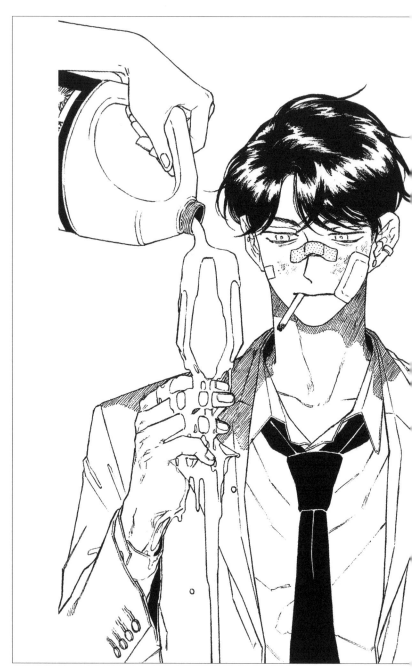

Good for You

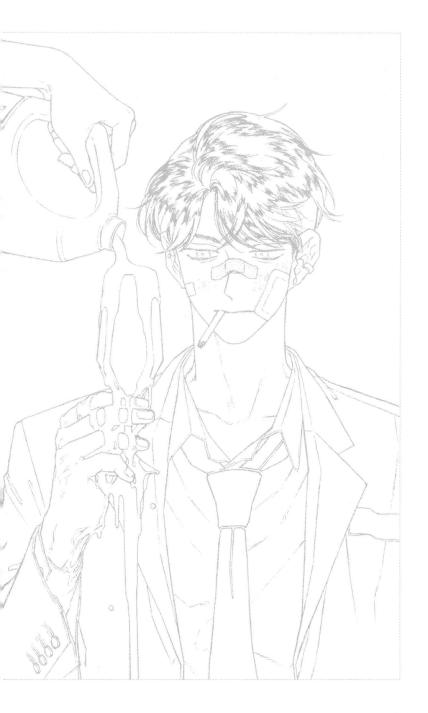

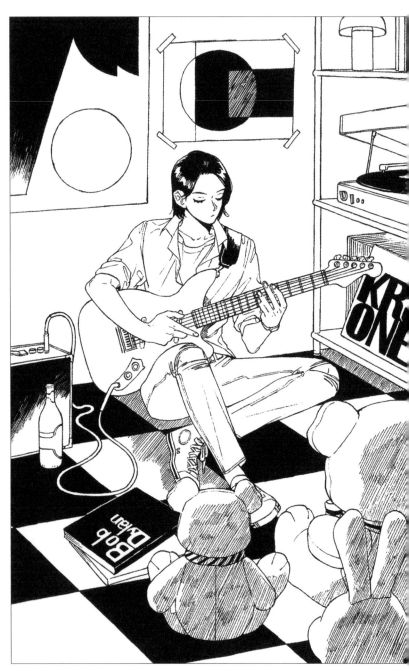

For the Young Audience

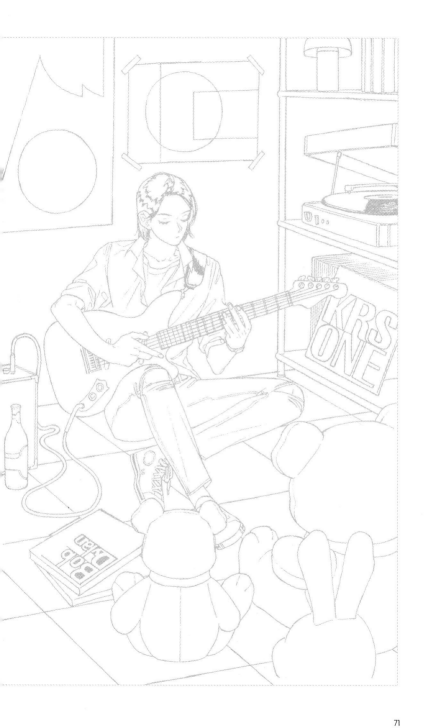

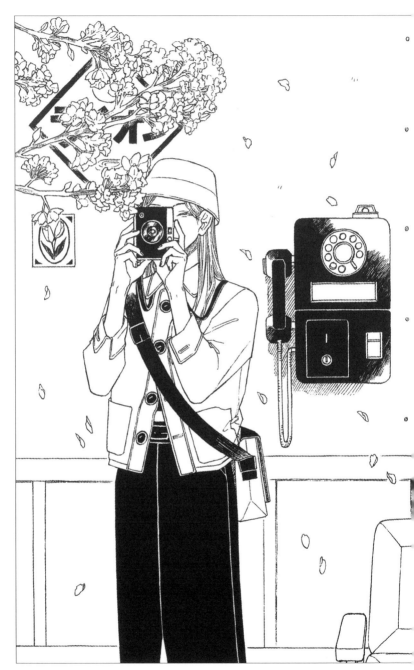

Cherry Blossom Rain

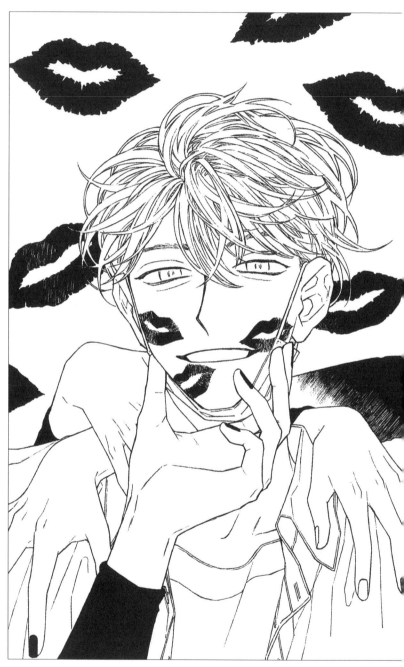

Kissed

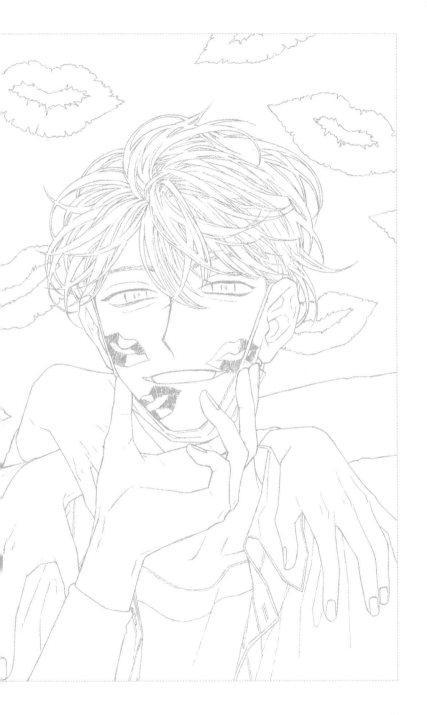

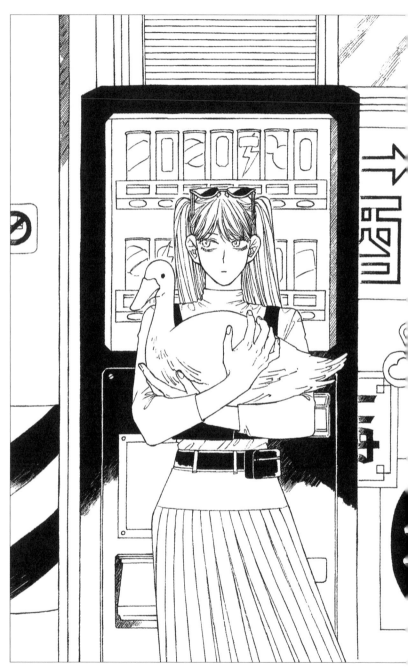

Hard-Boiled Duck

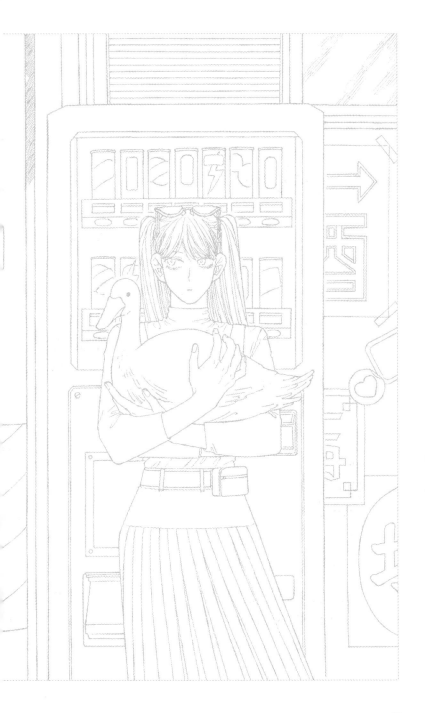

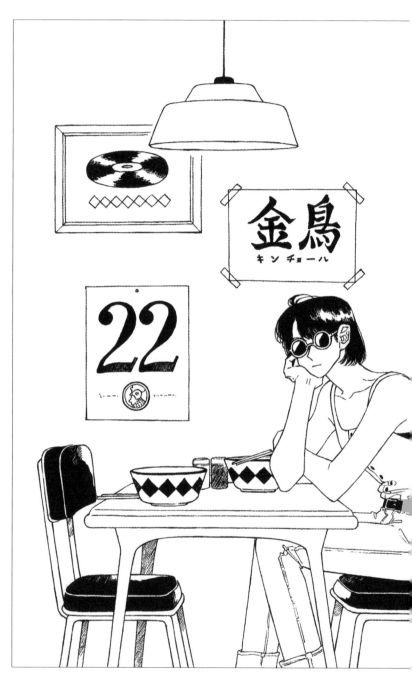

Late Lunch

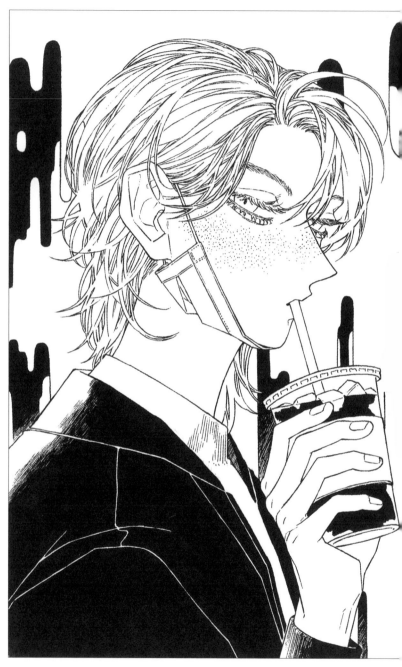

Melting Coffee

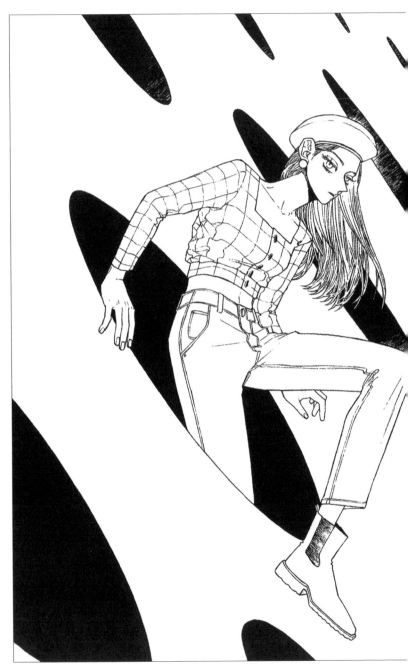

Swinging Sixties

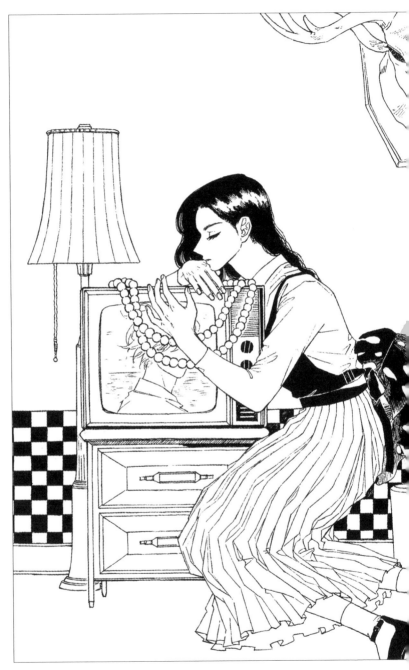

Fragments of a Memory

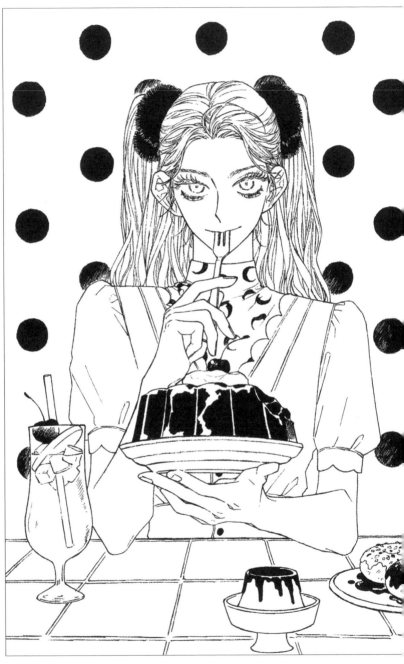

Summer Party

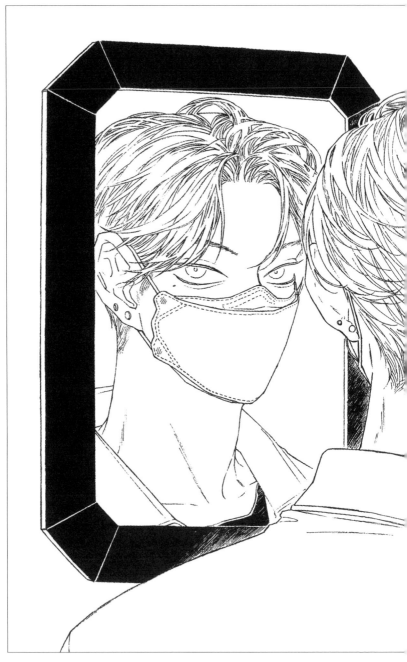

Eyes on You

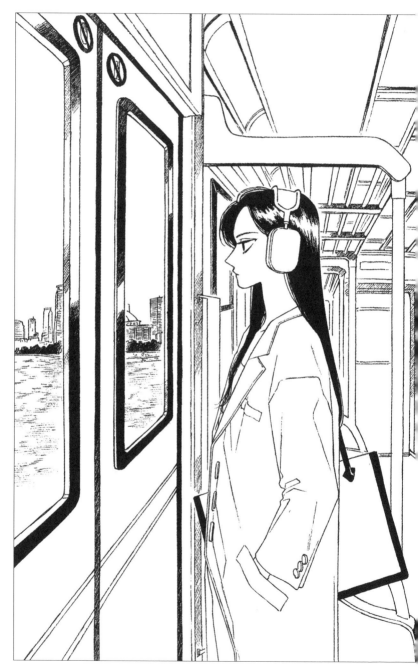

Home

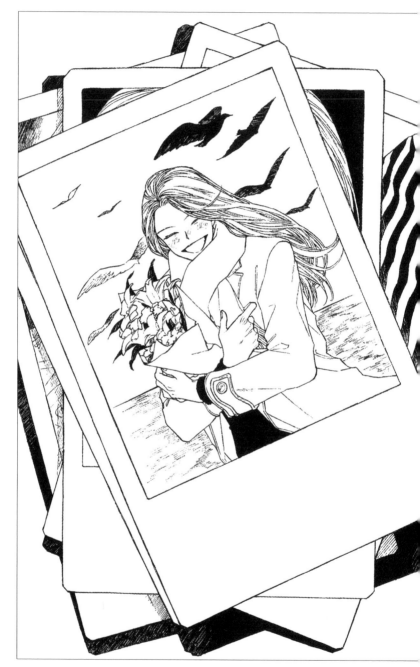

Your Waves

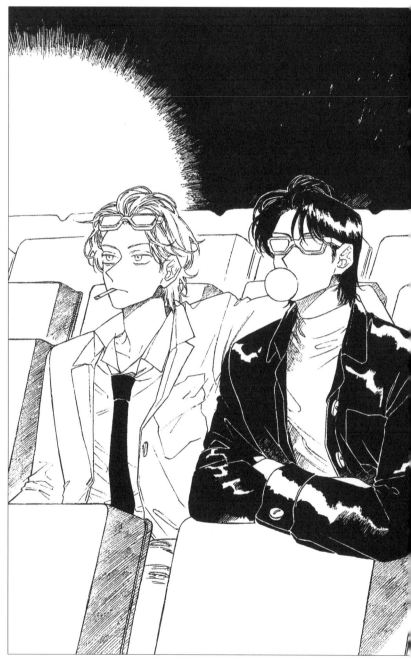

Cinema Club

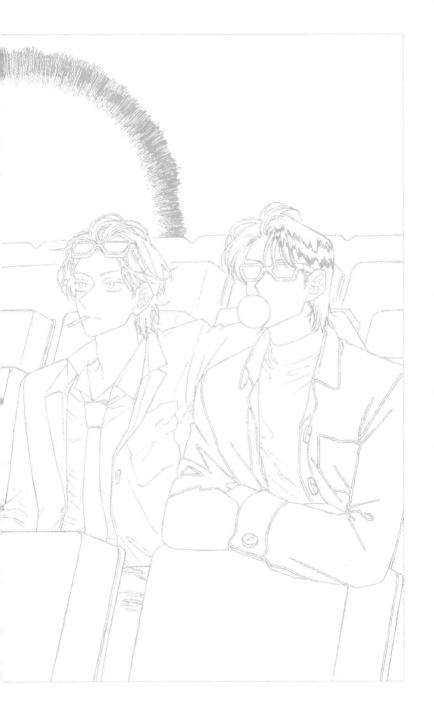

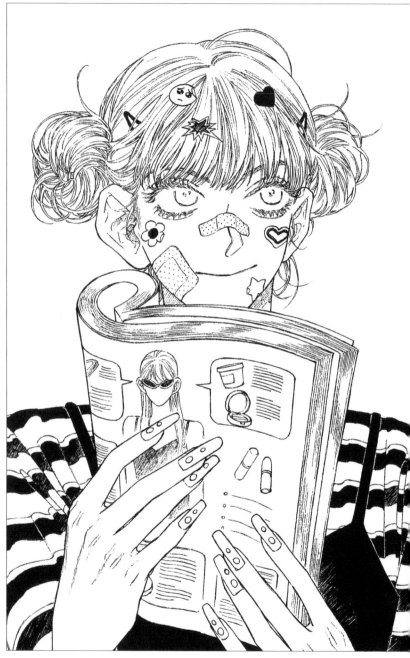

Little Miss Sunshine

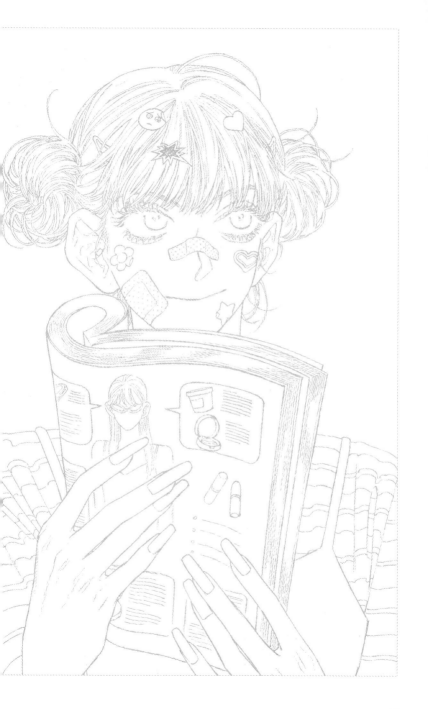

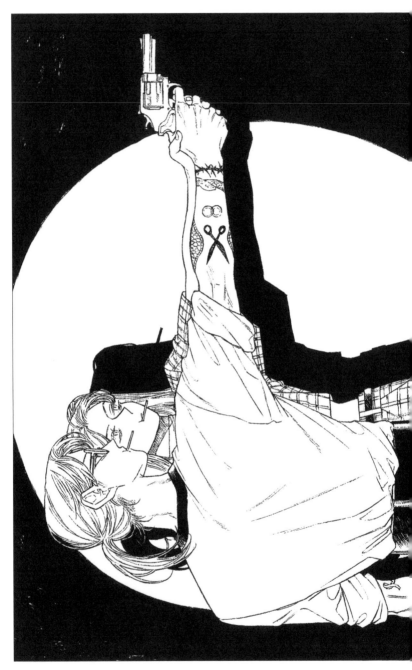

Reservoir Dogs

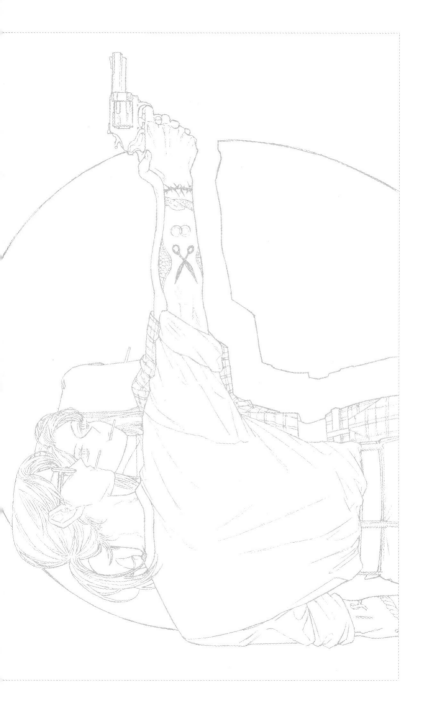

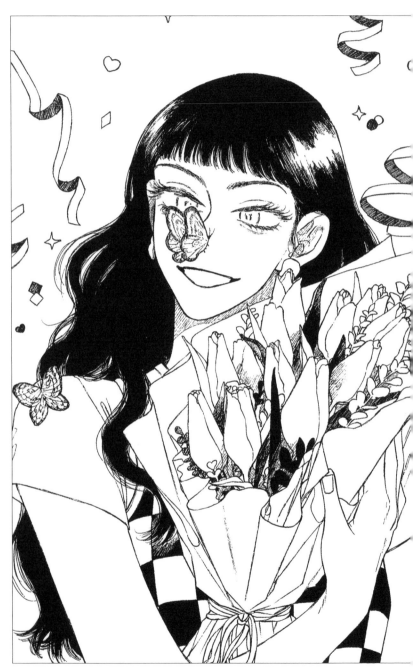

Twinkle Twinkle

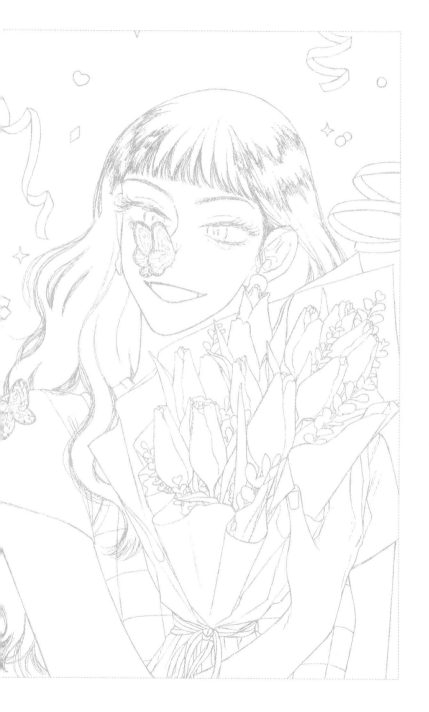

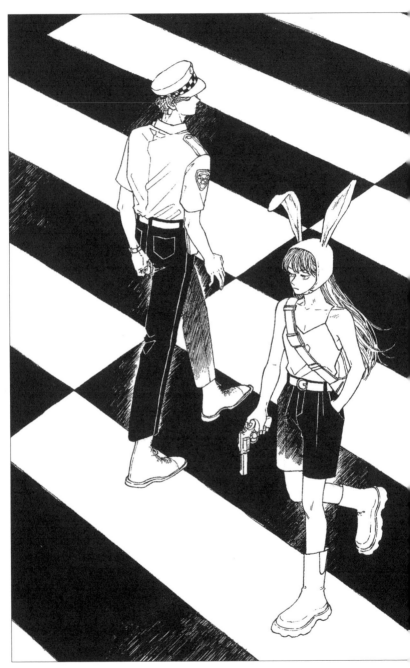

Bad Dream Baby

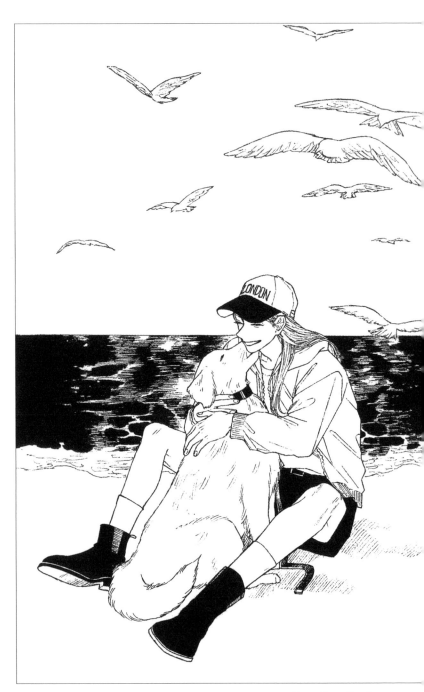

Always Happy Together

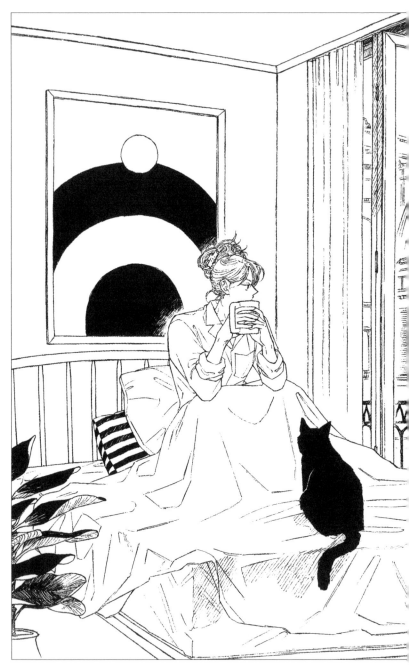

Sunday Morning

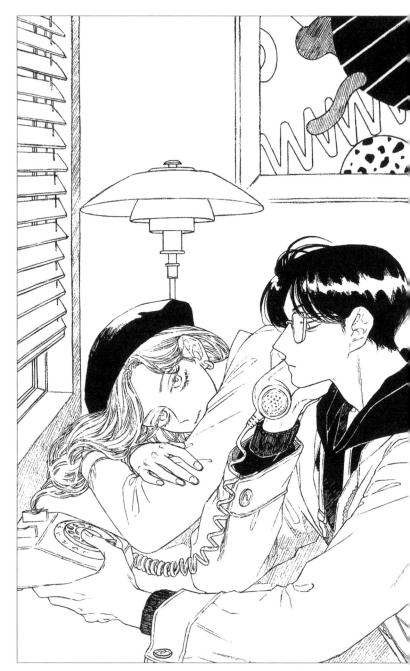

Calling You

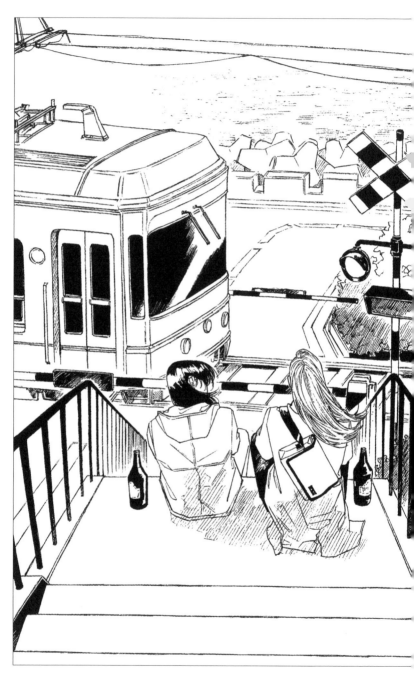

One More Thing for You

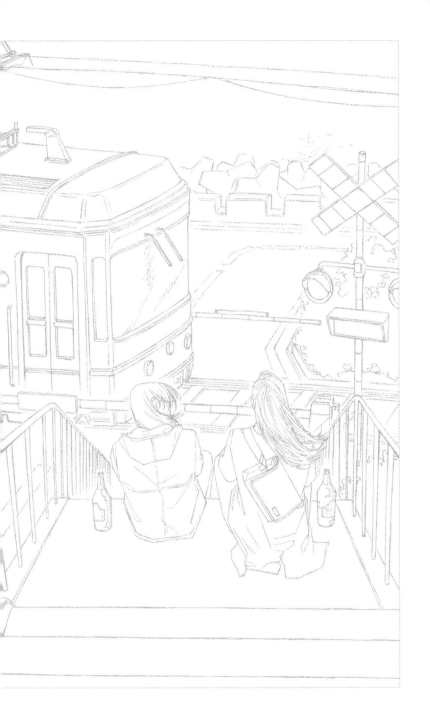